To ~~Aunt Liz~~
Cousin!

From Emmy, Zeke, Kip,
Willow, Flower, Prancer,
Lucy & Liam

12/05

Animal Wisdom

Animal Wisdom

More Animal Antics from John Lund

**Andrews McMeel
Publishing**

Kansas City

03 04 05 06 07 KFO 10 9 8 7 6 5 4 3 2 1

ISBN: 0-7407-3849-6

Library of Congress Control Number: 2003106498
Book design by Propel Design, Berkeley, CA

*L*ife is stressful for us humans. There's just so darn much for us to worry about—our weight, the weather, the economy, the environment, and, of course the possibility that at any minute we could all blow each other up.

Adding to our stress are daily annoyances, like detours, careless cell phone talkers, bad hair days, phone solicitors, crabgrass, and repairmen who never show up. It's so easy to ignore our place in the world and just focus on ourselves in our own little backyard.

But if we took a moment for a deep refreshing breath and then took a mindful look around us, we would notice that the animals we share this world with are living their true nature. If animals could share their innate wisdom with us, this is what they'd advise.

Stop. Recline.
Relax your mind.

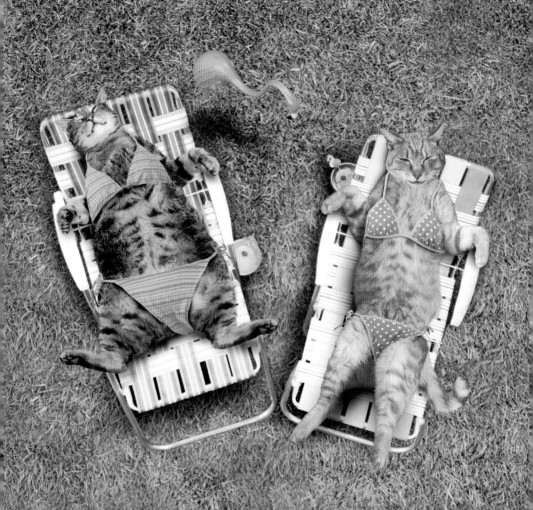

Unwind in
a bubble-filled
bath.

4

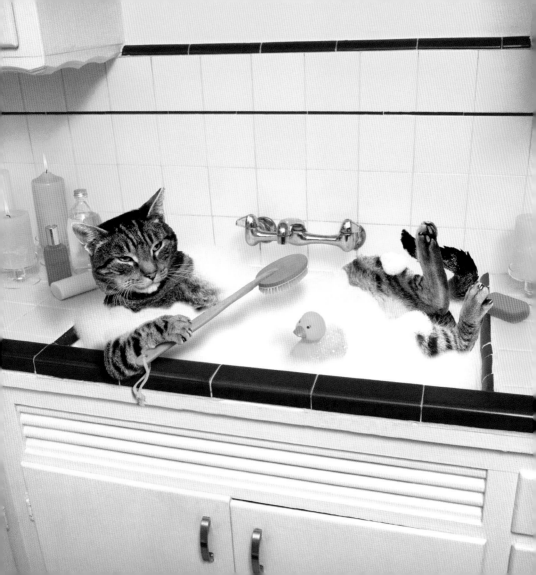

Work out the
kinks of
everyday life

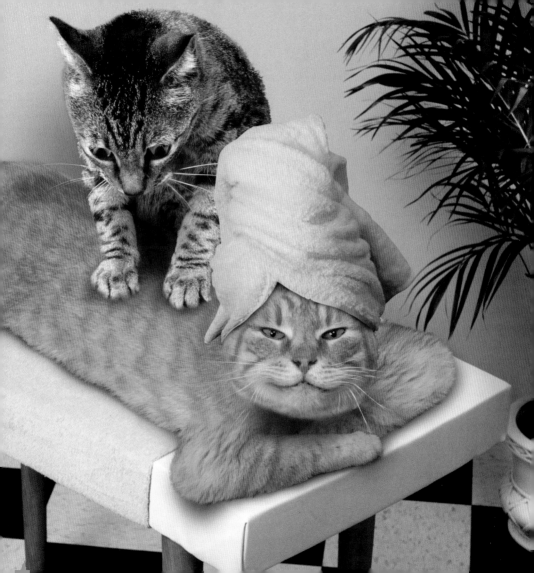

and discover

your own

personal balance.

8

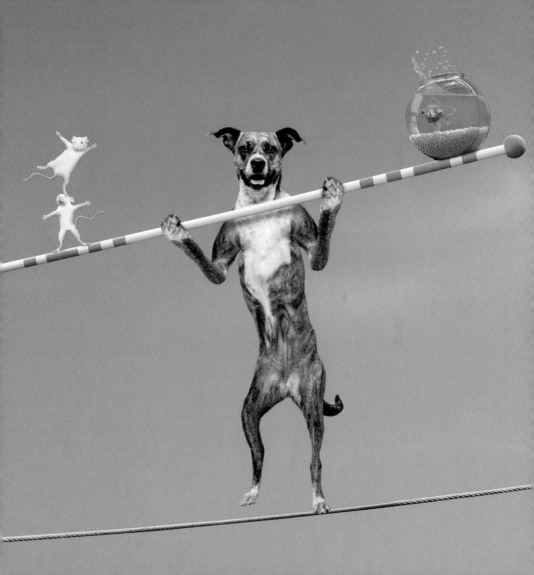

Observe the

world as it is . . .

whether it's madly flying

around you

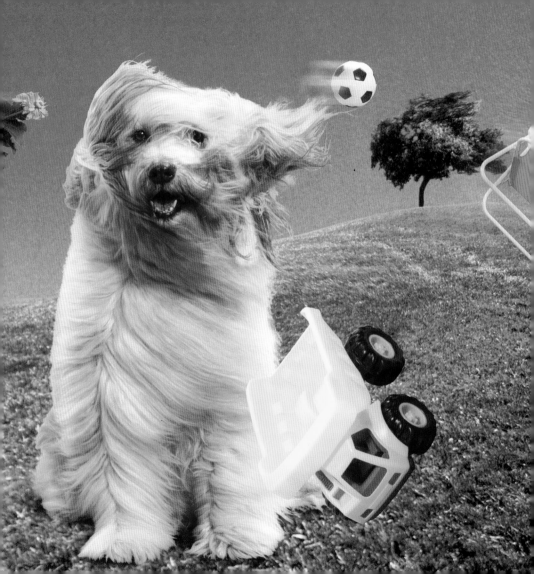

Or luring you with unspeakable temptations.

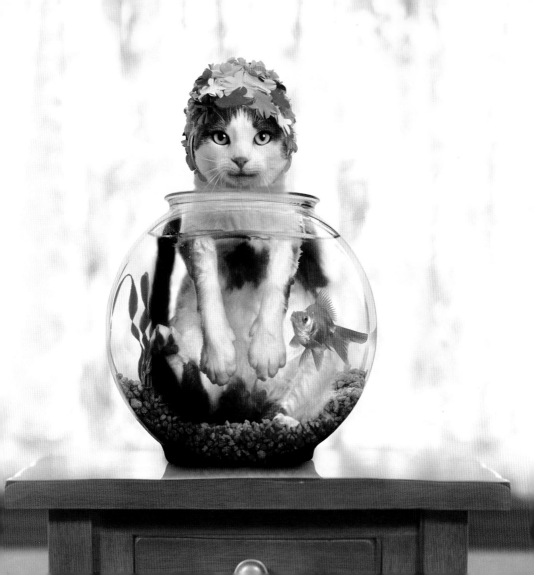

notice that small doesn't mean weak,

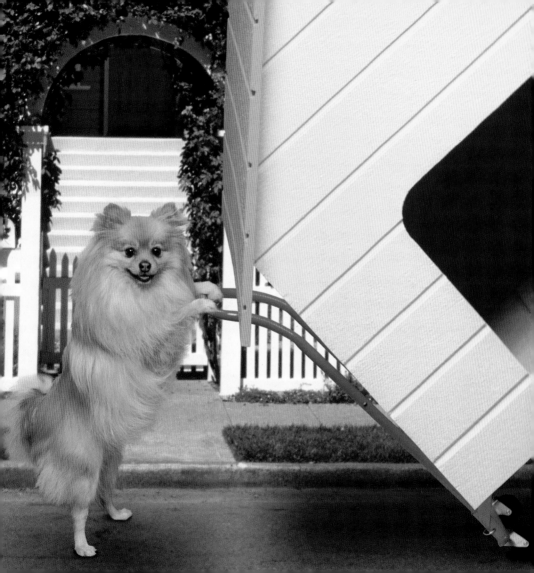

that big doesn't
mean strong,

16

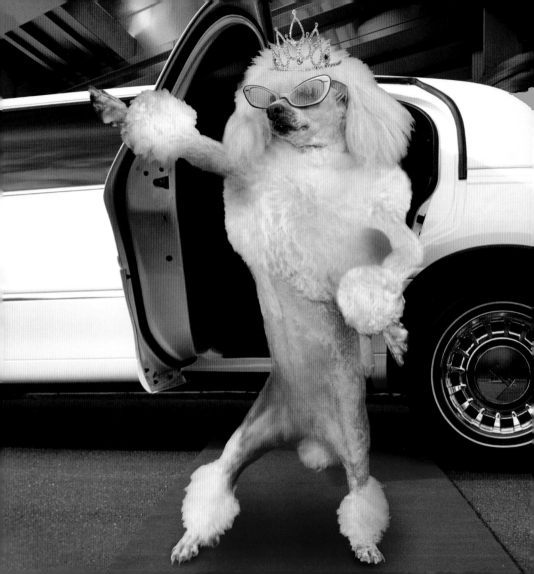

that sometimes (sigh)
conflict happens,

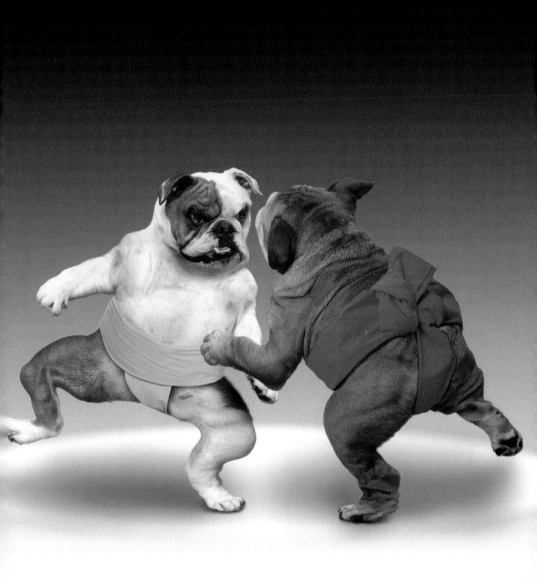

but that fun-filled
twirling
usually prevails.

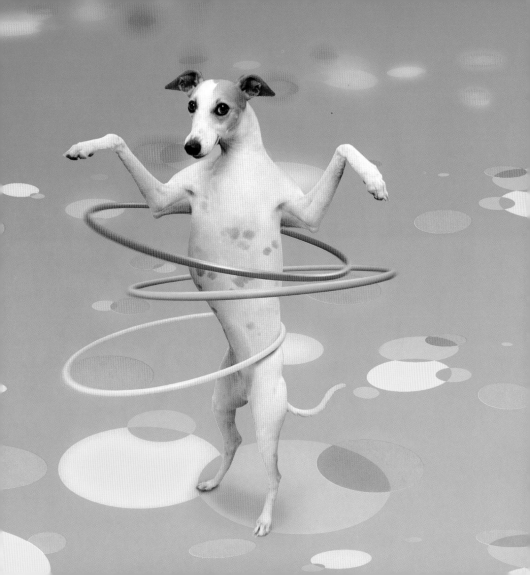

Pay attention to the creative force within you

22

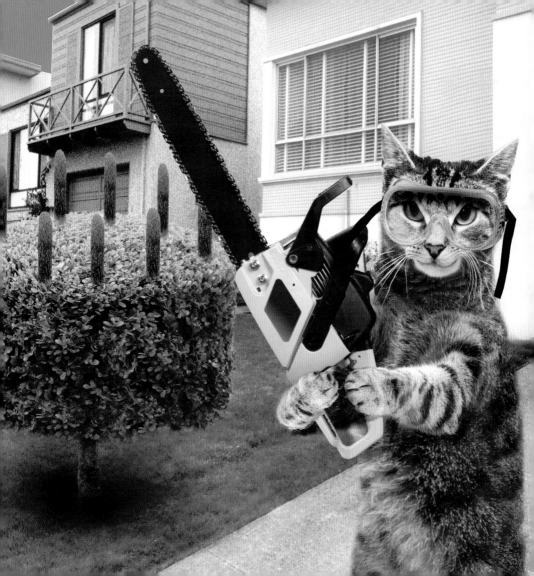

and the playful
vavoom-force
as well.

24

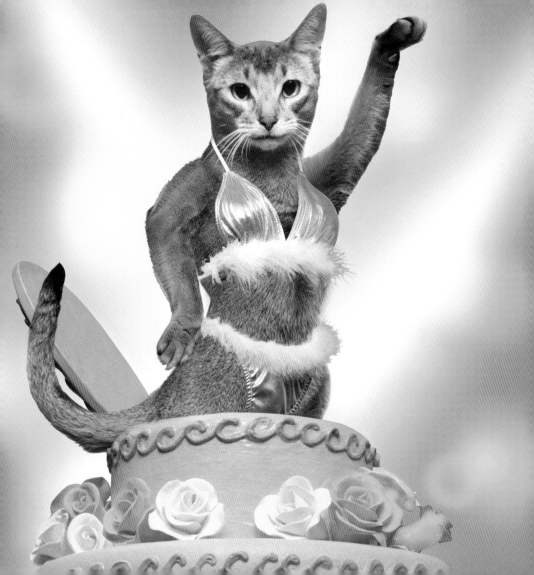

Reflect on the wonders of you . . . fly in your dreams,

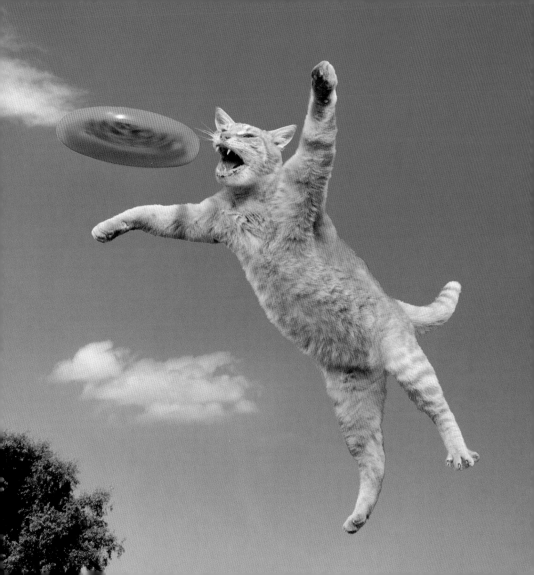

Skyrocket away from

your fears,

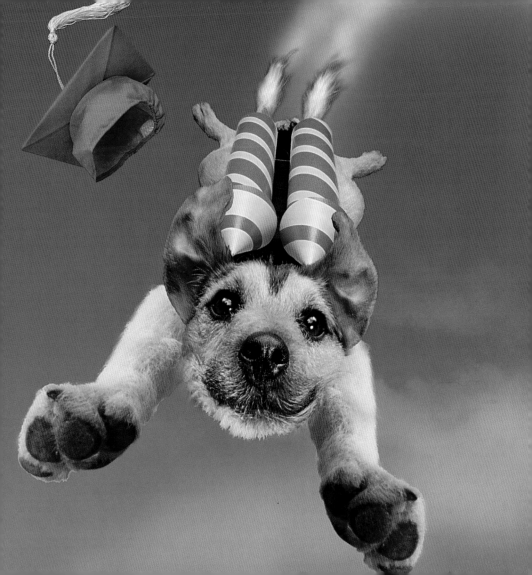

and bounce back
from cares and woes.

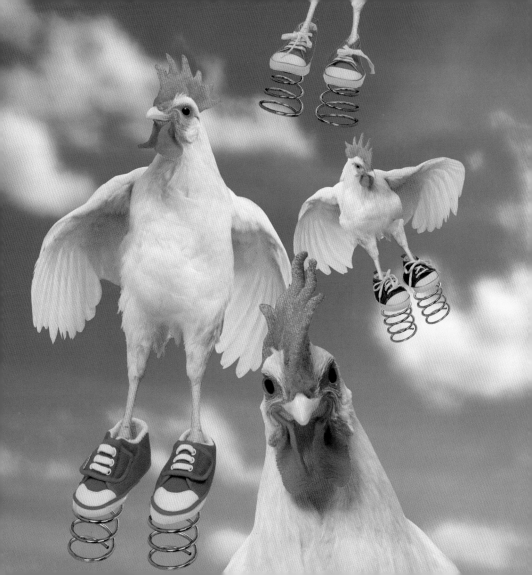

Reflect on

those you love . . .

it's really okay if they just

look at the pictures.

Their guardians
won't let them go
too far astray.

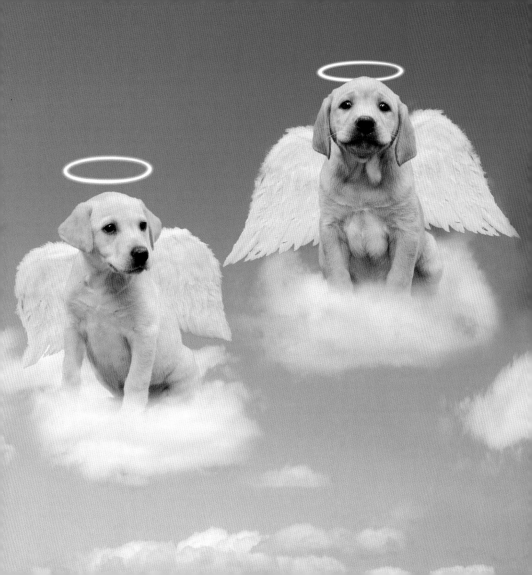

Share yourself . . .
bowl with a buddy,

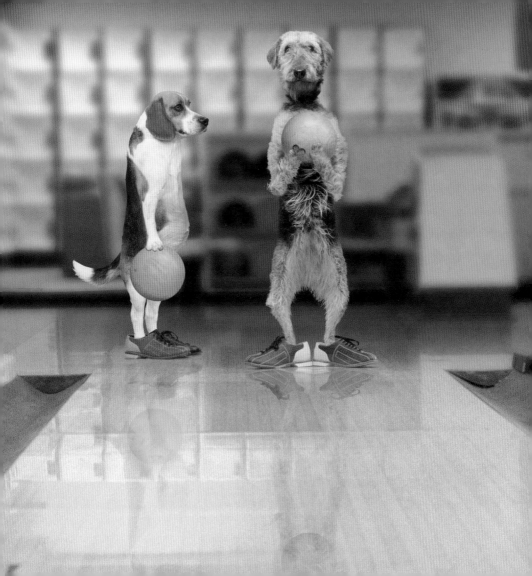

Coddle your companion,

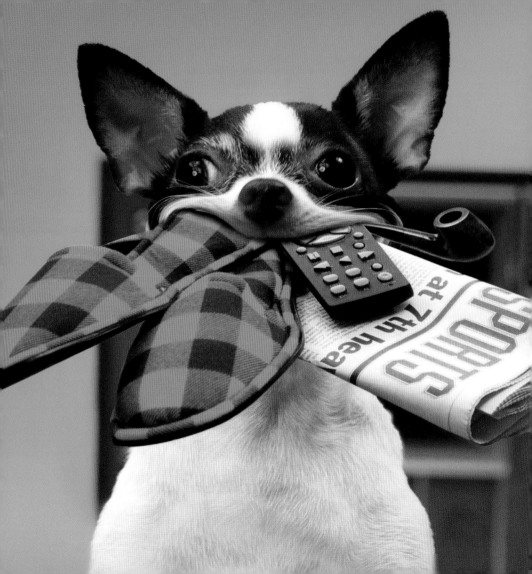

Split a cupcake
with a comrade,

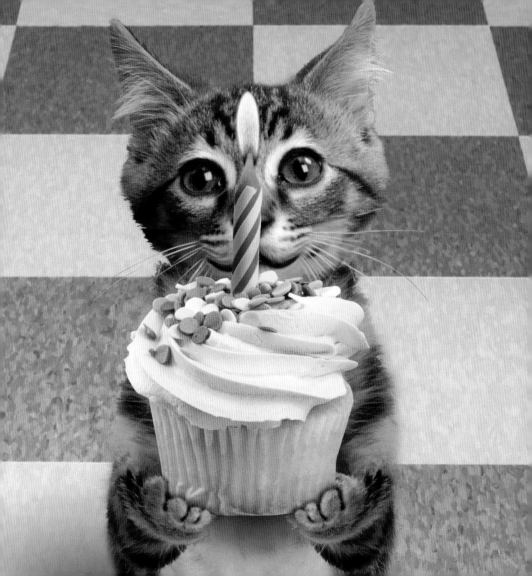

Or pack a present
for a pal.

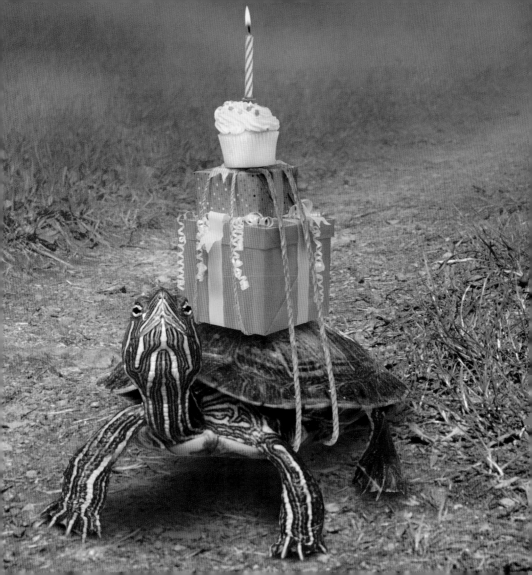

n ever begrudge.

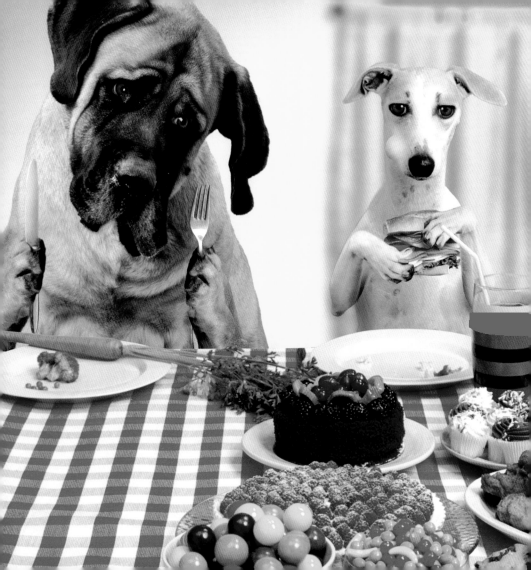

Offer your love freely . . .

give flowers on a whim,

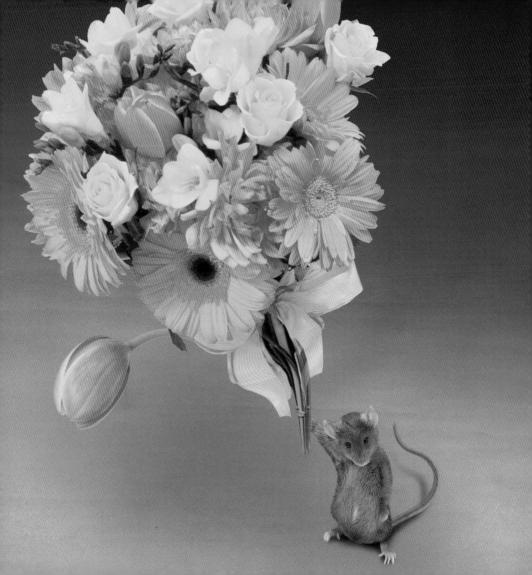

hug tight,

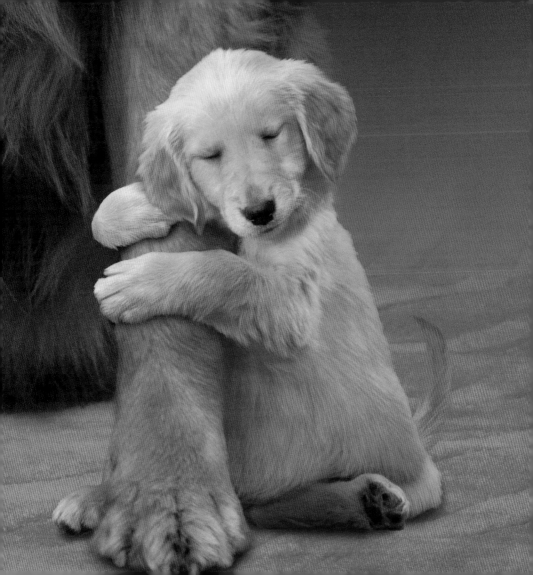

get together,

50

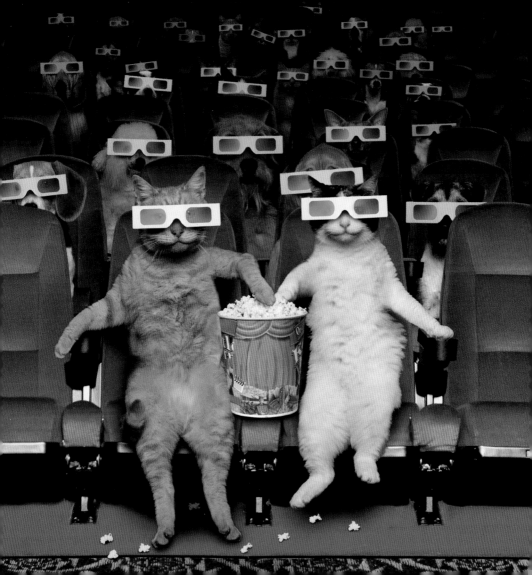

Snuggle warmly,

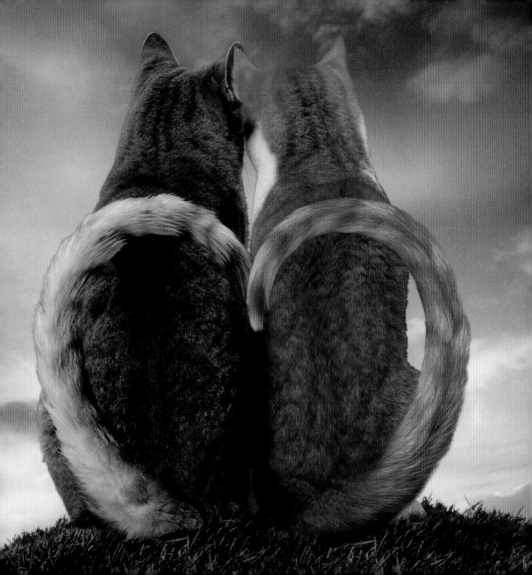

and nestle down.

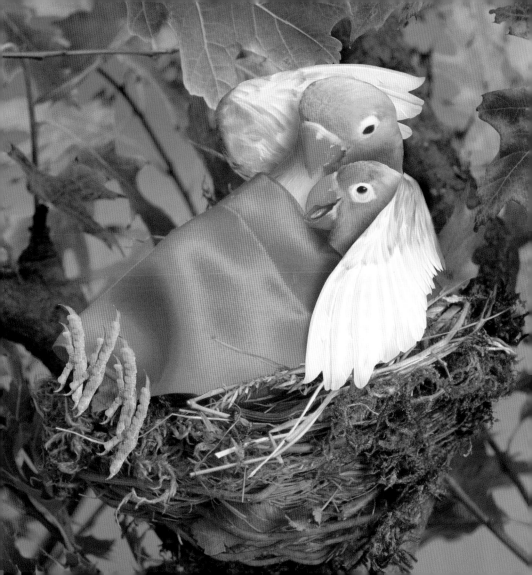

Keep good

energy flowing . . .

get silly,

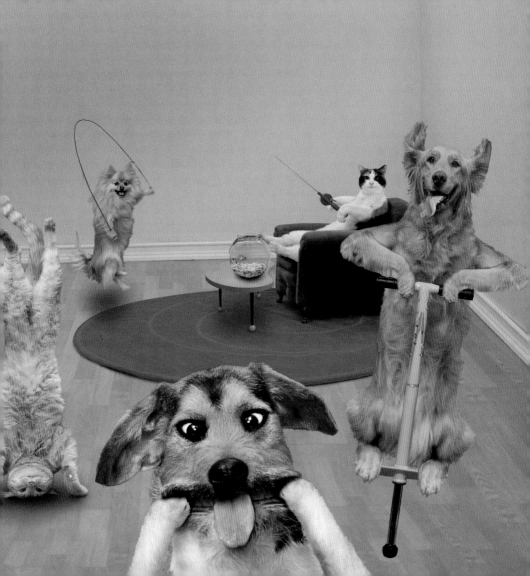

have fun as a team,

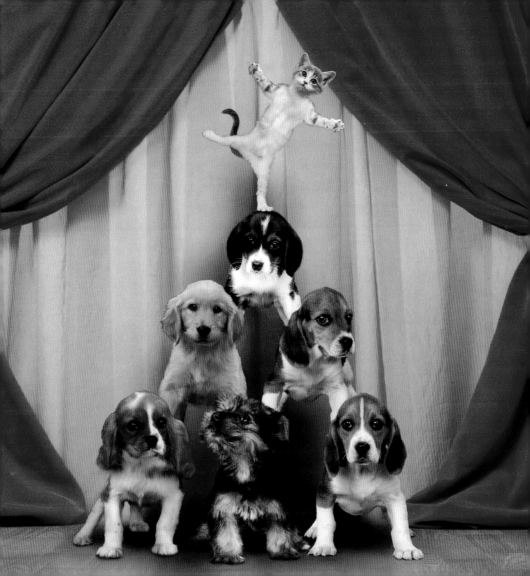

make merry,

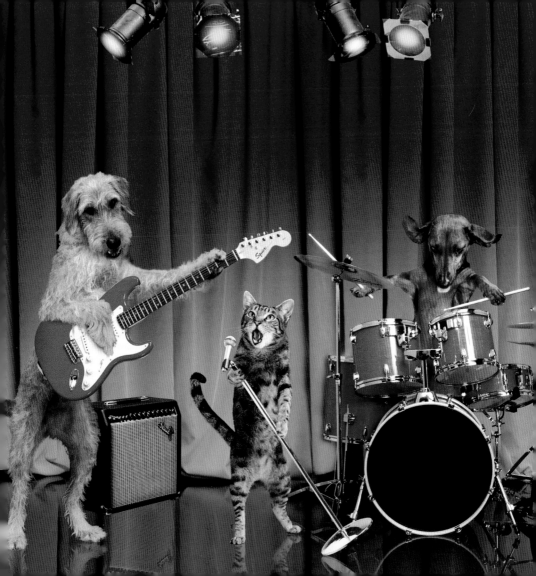

and party upside down,

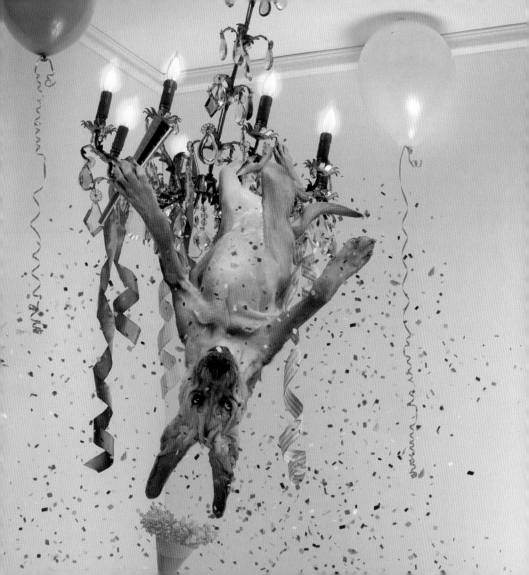

but watch out for flying frosting.

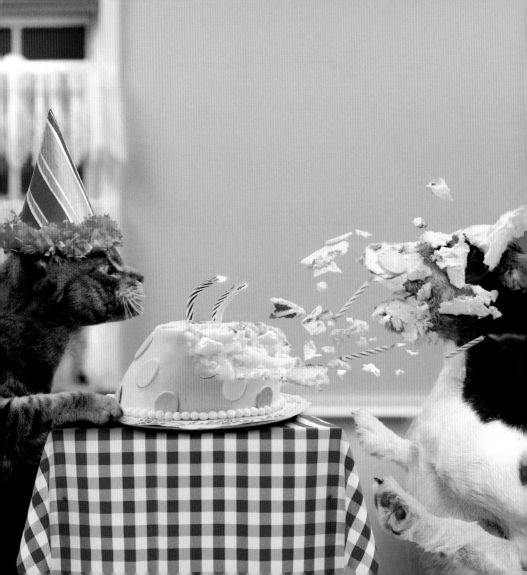

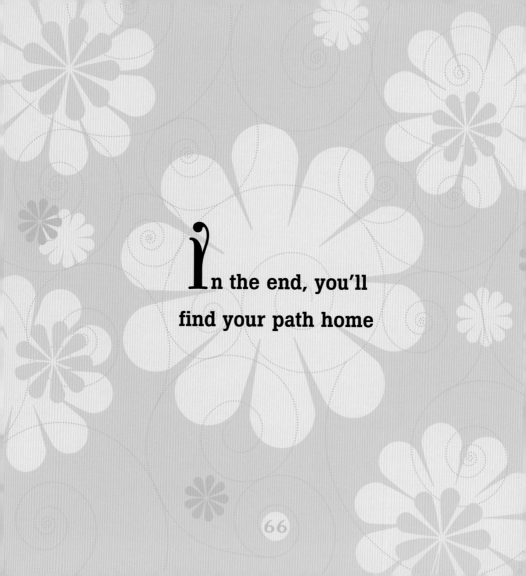

In the end, you'll
find your path home

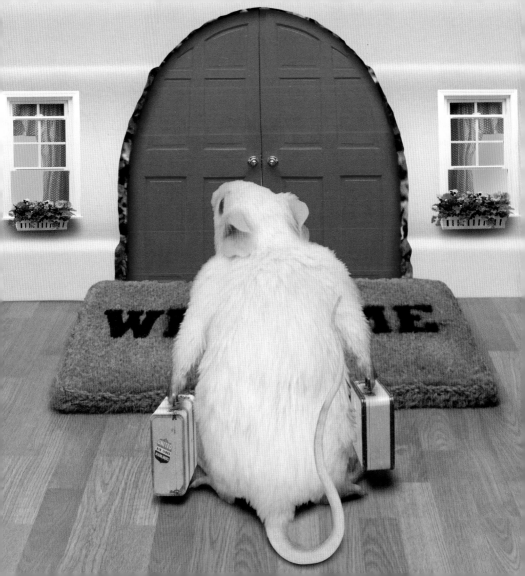

and roll on.

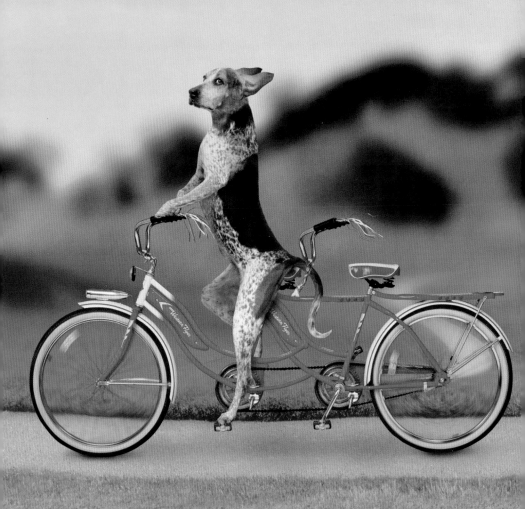

Then—

Stop. Breathe in.

Breathe out.

And be thankful for

being a part of

a great life.

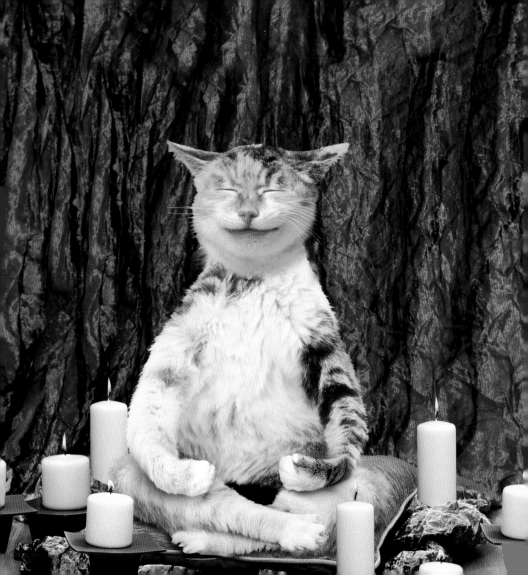

Special thanks to
Collette Carter and Peter Stein
for their creativity and enthusiasm
and to Bow Wow Products for
the animal talent!